THE ART OF EXCELLENCE

WRITTEN BY: MARK GATEWOOD

Copyright ©2017 Mark Gatewood

Published By: Mijini Publishing

Mijinipublishing@gmail.com

All rights reserved. No part of this book may be reproduced or recorded in any form or by any means, electronic or mechanical, including photocopying and or by any information storage and retrieval system without permission from the author.

Cover Design by Jamie Townes

Info.scootersart@gmail.com

Isbn13: 978-1545526156

Isbn10: 154552615x

Inspirations:

I've had the ambition to become a book writer ever since I was six years old. I actually remember the day I fell in love with the art of expressions in the form of a book!

Here's a little short story for you...

The week of Christmas me and my brothers, sisters and cousins were in the kitchen having lunch when my favorite uncle Keith came into the kitchen and gave us a book. The book was a story with all of us as the characters, we couldn't believe it! Our pictures were not only on the front and back of the book but all throughout the book as well! At the age of six I was very amazed to be a part of this book.

You see my uncle was very wise and health and education had always been very important to him. Uncle Keith had gotten this particular book created with us as the characters to teach us about the seven days of Kwanzaa. On each of the seven days of Kwanzaa in the book, we were part of a story that gave gifts to each other.

From then to now, for this book and many more reasons… I not only respect my uncle but I admire him as a family member and as a great man and I thank him for giving me a dream at the age of six years old to become a writer! A true inspiration…

I AM THE WORLD

I refer to myself as the earth and I refer to everyone else as Christopher Columbus

Because before Christopher Columbus explored the earth he and everyone he knew thought the world was flat!

Yet when they explored the earth they found out it was round, so now that I've given people the chance to explore me… they now see that I'm well rounded!

I think that one of the greatest gifts God has blessed me with is the ability to express myself

Another gift god has blessed me with is the ability to create productive perspectives to overcome unfortunate circumstances that I have been through.

I realized long ago that we are all different people but some of us face some of the same struggles and complications in life!

Going through the challenges I have been through and surviving has truly been a blessing from God

So out of gratitude and great conduct as a human of inspirational behavior

It would only be right to share my story with others with the intention to prevent others from making the mistakes I've made

CLEARLY I'M HERE

No part of any man

or woman's existence should depend on the accommodations of others

The sympathy of others or the acceptance of others

Ambitiously you should exist in your purest form of Excellence

Merely because you were created with the sky being your only limit

THE PEOPLES PEN

Each sentence you write is a reflection of your penmanship

So never forget to cross your T's and dot your I's

Each task or responsibility you take on in life crossing the T's and dotting your I's you can never forget

Because everything you partake in is a reflection of your desires of Excellence and Perfection

REWIND THE WAY DOWN

Be careful not to love the gratification from the mistakes you've made

That love may be the reason you make the same mistakes again

The ladder to life has its ways up and its ways down

The way down normally comes from you not having your ladder to life evenly stable or taking a step you wasn't supposed to take

The way that I fall out of love for a cancer; behavior or relationship

Rather business or personal

I study my old unfortunate outcomes and stumbling blocks of my past

Then fall deeply in love with a perspective that forms s strategy that avoids those circumstances again

STORY TIME

Everybody has a story!

Allow your life to create a story you can be proud of…

Everyone story gets them somewhere, allow yours to get you to a good place in life

Mentally, Physically and Financially

If your story has gotten you into some unhappy places…

Remember: your story still has a chance of a happy ending

As long as oxygen is writing on your mind, body and soul

THEY WERE GOOD SO I'LL BE GREAT

It's impossible to be one that is Great

Without respecting the Greats that were before you!

IT'S NOT A RACE IT'S A MARATHON

At the rate you're running, you'll be exhausted by the time you reach your destination

Even the memories of the journey you took to reach your destination will be exhausting

You will have moved too fast to have enjoyed your traveling

I AM AFRAID

I am afraid of returning to any of my destructive ways of my past!

I am afraid of being pulled into the nonproductive energies currently around me!

I am afraid of my future being anything less than great!

By me admitting that I'm afraid does not commit me to a state of FEAR!

It makes me aware of the way I was before and the way I am now

It makes me conscious of the Detrimental forces around me

It gives me the ambition to do all of the things that will guide me into becoming the person I want to be

Liberation without boundaries and self-acknowledgement without pride leads to a life without fear

INTENTIONS

Only associate with people who intend to bring out the best in you

Only associate with people with the intent to bring out the best in them

EDUCATIONAL FEAR

Don't be afraid to gain knowledge because you'll no longer be able to pretend to be ignorant

Many people avoid knowing, so they can avoid the responsibilities of knowing to do better

The best thing about the lack of knowing…

Is the gain of knowledge and the possibilities of growing…

FAITH

Never have total faith when you go to a person with a question

People are only human so they're never always right

It's not impossible for a person to be unsure about a situation or have the wrong answer

No one is perfect!

But always have faith when you go to God with a question because he's perfect and knows all

So he'll always have the right answer

Often, I've found myself unsure on how to solve a problem in my life

Unsure on how to make some of my dreams become realities

So, I would go to my friends or people I thought may have been able to help me figure things out and often I would end up in more of a stagnated mind frame than before I reached out to them

So, when I would go to sleep at night I would stay up having conversations to myself inside my head basically a lot of what to do's and how to do it's

At the end of every conversation I would say to myself "Please God help me figure it out" and no matter what the situation may have been about, I became more positive and productive instantly

I feel like those was the moments that I humbled myself enough to realize that as long as I put God first and seek everything through only productive positivity that will always be a manual route to get every question I may ever have in life answered correctly

Because my questions will be answered by God!

PRICE OF THE MIND

Not even your thoughts are free!

Everything comes with a price!

Thinking comes with a price of creating a perspective

GIVE YOURSELF

The best thing you could ever provide for your family is to provide yourself as a honorable person so that you can add honor and dignity to your family legacy

A good name is better than riches and gold

BALANCE THE CHALLENGE

From the mind of a man who faces challenges

I hold love in my heart so that hate balances…

For the women in my life who bring challenges

I hold forgiveness in my heart so a friendship balances…

CALM DOWN

Do not allow your inner dramatics and ego irritations to allow you to become in a violent state of mind which may cause you to want to bring or allow harm to come to the person that your heart had considered to be a candidate to receive your everlasting love…

SKIT OF A PLAY

I had a conversation with a woman one day and I asked her:

Am I not enough, she said you are, then I asked, am I not enough, she said yes you are

Am I not enough, she said why do you ask these things

Then why am I not enough

She put her head down and said my eyes are bigger than my heart and the world is bigger than you, you have already satisfied my heart but you have not satisfied my eyes

I see all that's in the world and that is the reason I want more… The eyes are never satisfied

THE MATH OF LIFE

The balance between life and death is happiness

You know you were born on a date and you know you're going to die someday…

In the middle of both dates JUST BE HAPPY

CONSIDER INSPIRATION

Never live your life considering who you are but always live your life considering who you want to become

Often people realize that they're not the person they thought they were

Often people claim an image without practicing the morals, principles or characteristics to support what they're claiming

If you focus on who you want to become instead of just claiming who you think you are, you will do all things that will lead up to you becoming the person you want to become

Before you open your mouth and say I'm this or that…

Privately consider your actions

And see do they support your thoughts…

Denial, Deception and Delusion

All leads to destruction

All of what I'm able to speak of is an example of the way my min use to be conditioned

But a cleaning of the mind and a new perspective has allowed me to overcome

SAFETY PREPARATION

There is no such thing as the safest place in the world

Yet the safest people in the world are the people who prepare for the afterlife

CONSTRUCTION

A lot of the things we do in life cannot operate without a person physically being there, such as jobs, relationships, movements or organizations

All of the things I just mentioned can in fact operate without your physical presence if you choose correctly and build correctly

Only build or become a part of something that can work for you…

Without your physical presence

If you do this, you will have no problem stepping away from your subject to attend to or build other subjects

Build things to work without you so that when you're not around they still work for you

THE MATH OF THE HEART

The balance between love and hate is peace

You can't love everyone, yet you don't have to hate anyone

Just be peaceful with them all

KEEP GOING

I always heard people use the phrase
'Stop before it's too late'
But I've never heard people use the phrase
'Quit before you become to great'
Gifts, talents and blessings

Once a person marinates on the energies to make their dreams become a reality

The next step is to rationally come up with a process, step by step on whatever needs to be done and create a concept on how to obtain lucrative benefits from the hard work that you intend to put in

Once you realize you have a concrete method of all the ingredients needed to make your dreams become a reality

The next step is to obtain all that is needed to get your process started

Do an strategic inventory, then divide your productive energies in all of the subjects of your matters

There will always be critics

There will always be fans imposing their method of how to win a game they're not playing

One at a time, pay them no mind

Your goal is the finish line!

TOP 5

The 1 most important thing that I value is my relationship with God

The 2nd important thing that I value is my perspective

The 3rd important thing I value is my family and friends

The 4th important thing that I value is my ability to be strong enough to survive through adversities and my abilities that allows me to be strong enough for others

The 5th value I hold dear to me is the gift that God has given me the gift of having honorable values and counting blessings

CONVERSATIONS

Let people keep talking about you until they realize they ran out of bad things to say about you

They have no choice but to talk about all the good things about you

The whole time you were on their mind

You were consistently on your grind

The things that may have not been so good about you- NO LONGER EXIST

Now all their left with is greatness

The conversation will change, but you will still be the topic

SELFISH BRAVERY

No man or woman should be brave enough to say he or she lives for unity

Allow a single day to go by

Without an intention to service the community

The best way to unify in

Love

Is to unify and resolve the matters

Of hate

The best way to unify to remember

What has been destroyed

Is to unify and discuss how to create

The expression to resolve an issue or overcome something or make a situation better is far more than venting when the chance presents itself or constantly displaying emotional and mental discomforts

If you continuously are aware of any conditions or treatments rather those issues be mental, physical or financial to you or your love ones

Then every day the other side of your conscious alarms you on how to better those conditions productively

Remember you do not have to have an enemy to love yourself, you do not have to seek to destroy anyone to better yourself

COLOR BLUE

Black is the color that is used to describe my race
Yet black is not my favorite color

My favorite color is
 HUMANITY

As people, we all can choose to do wrong

As people, we all can choose to do right

As people, we all can promote love

As people, we all can promote hate

As human, we are a creation of

God

Whom he favored with a conviction called

Great

Man is God's greatest creation

Rules of the earth, so why does it matter complexion at birth

SIGN OF SIGNS

Over all of the years of memories I have from relationships and close bonds with people, I have realized that a sign that a person loves you or likes you to a high degree is when they start to point out your flaws as good qualities

It's a gift and a curse

One day a woman I had just met invited me to a dinner party with her and her friends. I had decided to attend it. I liked the girl a whole lot so I went and bought a new outfit and me and a few friends went to the party.

While I sat at the table I was sort of quiet and the woman who invited me said to her friends look how smooth and humble my new friend is.

What she didn't know is that normally I'm not quiet, but I was silent that day because I was being shy and nervous because I really liked her.

She noticed my flaw as a good quality and it worked in my favor at that time, but before I knew it, I got bored and decided to leave early because I couldn't relax with the woman and her friends who I admired.

I remember many more situations that was similar to that one where there was a time a person who counted my flaws as good qualities.

For instance, when I couldn't do something correctly, I would get quiet and find another trade or hobby.

People would say he likes to do many things but what they didn't realize is that I would give up on things I felt I couldn't do correctly.

The gift was that my imperfections were noticed as perfections. The curse was that the less my love ones helped me with my imperfections, the longer it took me to reach excellent perfections.

NO THIRST

Always want a woman just enough to enjoy her while she's with you

But never enjoy her so much that you'll do anything to get her back

No woman is worth desperation

It's in a man's nature to seek, pursue and go after what he wants, but always remember…

A meal shared between two people is only a date when the hunger is the same between them

Always be alert, that one day there will be a woman that you will enjoy to the point that you will want her back

The only difference is that she will have enjoyed you just as much as you have enjoyed her so you won't have to get her back

Because she will forever be with you

After many failed romances and often finding myself wondering is the person I am emotionally connected to me or even thinking of me

I came to the realization that it would be less complicated to my mind, body and soul if I only pursued a woman just as much as she pursued me

EXPERIENCE

I want to experience each moment of my life passionately

But not with too much passion, only enough to simmer in all of my experiences

If I am remembering correctly

Most of all my most memorable levels of great pleasure seemed to be as great as it can get for me, at least that's the way I unconsciously felt at those moments of my life

Those moments seem to be the briefest stories I can tell about the best times of my life

Possibly because I didn't relax and enjoy the situations for face values and I looked into those encounters too much

Or possibly because I did the opposite and the moments that I should have enjoyed sincerely I cherished them merely

Everything should be don't through excellent moderation

The way to add humility to your greatest moments

Is through rationalizing relaxation

HUMANLY TRUST

As humans, we can never fully trust in ourselves

Due to the fact that we cannot trust that there will be consistencies in any of life's circumstances

Often in life we plan to deal with people with our greatest of characteristics and qualities

Often in life we are faced with unexpected circumstances that gives birth to characteristics that may be harmful to ourselves, our family, friends or others

As humans we should never be in fear of ourselves

Instead be in good fear of God

By living all of our past with remembrance that without him we are never truly protected from ourselves or others

BAG OF WHO'S AND WHAT'S

I've learned that as men and women we like to hold on to ourselves and some people in our lives tightly because of the comfort and remembrance of helping us identify with who we are

As humans, we all have parts of us and also people in our lives who are not good for our mind, bodies and souls individually or collectively

I've also learned that every given has a given

Meaning that every part of ourselves that we get rid of or every person that you get rid of will be replaced by a better

It's like cleaning house, before you can bring in any new furniture you have to get rid of something that's not functional or taking up space and does not look good in your house

QUESTION:

So, what doesn't look good in your house?

Reflect on yourself and learn what parts of you are not good for you

Remember

Every given has a given

So, if you give a person up prepare for a better

CROWDED OPINIONS

Never be in a crowd where all of the people there are only there to seem intelligent

Because all of the wisdom you share, they'll try to make it seem irrelevant

Most of the times I've sat in a circle to discuss problems at hand and the same thing always occurs...

People are more so worried about being the person who came up with perfection than uniting with sincere productive energies to solve the problem instead of medicating it with egotistic ideas

LEADING EXISTENCE

Great leaders did not become great leaders by

Focusing on the title LEADER

They became great leaders by having a

Dream and a vision

By doing everything it took to see it become a reality

By doing so, they gave the people something to follow

That is what earned them the right to be called great leaders

Never focus to much on what you want to classify yourself as, instead focus on doing

The things that will lead up to your classification

APOLOGY PAYMENTS

If you are successful or ever plan to be successful at anything, the number one thing you should prepare for is

Your apologies for arrogance

Most people are one day successful at something in their lives and most people get arrogant when they reach a level of success

Not all people, but most people success and arrogance sometimes come hand in hand

Arrogance is not a guarantee that comes with success but it is a possibility

As long as it's a possibility you need to prepare your apologies

This is an apology you may apologize

You may not have to verbally use

By preparing your arrogance apology, you will always have a reminder to always avoid the characteristics that creates arrogance

Success without arrogance keeps you humble

No matter how many accomplishments you achieve, as long as you're humble people will like you as a winner

Humility is one of the responsibilities of success

PRAYER

The best thing you can ever pray for other than good health is good intentions

The second best thing to pray for is that all of your intentions become your intentions

To me prayer is an honest time to self to identify your fears, your weaknesses and insecurities with caution and sincere prevention with the help of God

The way that I keep in mind the things I fear to do or neglect

Is to keep in mind what I pray for

A JOURNEY WITHIN
SOMEONE ELSE...

I had started helping out at a food diner during the publishing of this book and I was blessed to build a great friendship with my co-worker Becka.

My first day at work we talked a lot about our lives and our current struggles and joys. She began to tell me about her son Rayf and his journey of being a child with down syndrome. My heart instantly warmed up listening to her tell me from past to present about the life and complications of her and young Rayf. It reminded me so much of the love my family had for my sister Keilley who had passed away at the age of 15 due to the injuries she had from a car accident when she was only 18 months old.

Without social media being a subject at the time my sister was injured she still was very famous back then and had many fans and followers, in fact everyday of her life she was always in a room full of people who came to see her. She was joyful and happy despite her injuries.

My father and stepmom taught me the lesson first hand what family means because they went through many ups and downs but no matter what Keilley was the first priority and even though times wasn't easy, all of her needs were met and she was provided a joyful life.

So, when Becka opened up to me. I understood her joys and struggles.

I asked her to be apart of my book just to tell her story and I thank her for letting me be part of promoting the love she has for her son Rayf.

Thanks again Becka

And thanks Mom and Dad for showing me the strength in family values.

BECKA STORY

All of my life I dreamt of having a child of my own. Everyone always said how great I was with children. As I started getting older I decided that I was ready to become a mom.

For years my boyfriend and I tried to get pregnant but it seemed impossible at that time. One day I woke up with really bad pains in my stomach so I went to the hospital and the doctors informed me that there were some issues with my ovaries and that there was a good chance that I would never be able to have a child. This news broke my heart.

The doctors told me this after three years of trying to conceive. It was very upsetting, so I just gave up trying to have a child on my own.

I continued on with my day to day routines working at the diner trying to provide a life for myself. At the time I was working forty hours a week. A few months had went by, it was just a normal, usual day at work, but as soon as my shift started I didn't feel too well.

Every order that I was going to prepare made me feel nauseously sick. I got off work at 10pm and went straight to the store and bought two pregnancy tests. Both were positive!

Believe it or not I took ten, yes ten pregnancy test. I still couldn't believe it. I started freaking out. So,

I decided to make a doctor appointment and sure enough I was almost two months pregnant.

I couldn't stop crying with excitement. A couple of weeks went by, things stated to take a turn for the worse. I began to get extreme backpains, stomach pains and wasn't able to keep any of my food down. I knew something was wrong, so I went straight to the hospital.

The doctors were very concerned for the baby's sake due to the amount of pain I was in. the swelling and my blood pressure was through the roof, so they admitted me.

I was in the hospital for a very long five days. The baby and I were fine but if any pain started again I would have to go back. I continued going to my regular doctor appointments where they would check for weight gain and listen to the baby. Over the next few months I had noticed that I was gaining a lot of weight. So, they asked me to go over to another building and get checked out. When the doctors did sonograms and everything was fine. The doctors had said it seemed to be a healthy little girl and estimated that my baby would arrive August 14, 2012.

Well just to let you know the summer of 2012 in Baltimore was one of the hottest summers in

Baltimore plus I was over 200 lbs, so that didn't help either.

At this time, I was also in the process of moving, needing a bigger apartment for when the baby arrived. I spent one whole night packing and then went to bed because I had a doctor's appointment the next day.

When I got to my appointment the next day the first thing the doctors said after checking me was, "go to labor and delivery, you'll be having this baby by tomorrow". I almost fainted.

I wasn't for sure if I should be scared or excited. I was definitely nervous though and my mind was racing. I had to call my family and get them to go to my house and unpack the babies stuff.

All I could think about was the fact that my apartment is way too small, we had three weeks left until our moving date into the new apartment. I remember my mom telling me everything will be alright, don't stress about the little things.

Well it was time for me to have the baby and it didn't go as smoothly as planned. As I started to drop my blood pressure started going up. I remember them telling me to keep trying...

I also remember them saying, "we're not losing you, this baby needs a mom, you need to stay with

me!" and everything went blank! The next thing I remember I woke up and the baby was crying.

The doctor said it's a beautiful baby boy but they didn't allow me to hold him at first, I just kept asking was there something wrong with my baby and was he ok.

Eventually they handed him to me. He was so beautiful, I couldn't stop staring at him. Then a doctor whom I never met before came in my room and says, "your child has down syndrome".

This was a big shocker for me!

My family also had, had a similar reaction to the news. He then says we have to run a few tests being that your son was born a month early.

All of the test came back great, he was healthy despite his circumstances. The doctor informed me that there may be some problems in the future with his health. It's typical with a child who has down syndrome.

I started asking questions as to why I wasn't tested or ever informed that my child had down syndrome, and I couldn't believe that one of the nurses actually said, "well if you knew, would you have aborted him?"

The answer to that question was NO, it just would have been nice to be prepared and to get a chance to learn about this disability.

I was blessed with a beautiful baby boy, disability or not I was still going to love him the same. He may have a disability but his misfortune does not disable the unconditional love I will forever have for him. No matter what I would love him the same forever.

Yes, I knew there were going to be struggles ahead but none of that mattered. I was going to fight to get my son all the help he needed.

A month went by and he began having problems with his heart and eye sight. We began going to the heart doctor once a week because he had holes in his heart and an opening in one of his chambers. We believed it would heal in a matter of time, just a matter of patience but this was a scary thing to think about.

The eye doctor told me he had a lazy eye and he couldn't see to well. So, he would eventually need glasses, then I was informed that Ray would have to begin doing therapy. The things that we take for granted like walking and talking and such things as even eating were going to be difficult for him.

The state provided three therapist, they came to our home three times a week. The physical therapist said that there was a good chance that Rayf might not be able to walk, for the first year he couldn't even sit up on his own. Trying to do therapy, visiting doctors and working began to take a toll on me.

Many days I just cried because I was so tired, yet I refused to give up. I had to be strong for my son and help him in any way that I could.

So I continued to encourage him, he finally started rolling and sitting up close to two years old. I was so proud of him, it was a huge accomplishment. With that accomplishment it gave me more hope than I already had. I knew if I kept encouraging him, he was going to walk one day, I knew it was going to be at his own pace.

When they said your child may be in a wheel chair for the rest of his life, it was the most heartbreaking thing. Just to think that my child wouldn't be able to do things that other children can do such as even just being able to run…

In my mind and heart I just wasn't accepting that. I continued to work with him and things started looking up for him. His holes in his heart closed and his eyesight started to improve. God had answered my prayers.

After two years of cardiology we never had to see a heart doctor ever again. It was a blessing. We did continue to do therapy and at this point Rayf was beginning to stack blocks, say a few words, even drink out of a straw. The drinking from a straw was a huge accomplishment. When I said his muscle tone was really weak, I didn't just mean his legs or back, it was the muscles in his face as well.

I never take anything for granted, because small things like that some people aren't able to do.

Not too long after learning how to drink Rayf began standing up as long as he had something to hold on too, I was beyond excited. That just meant the therapists and myself were getting closer to getting him walking.

Well Rayf was close to turning three years old and the therapists informed me that they thought it would be best for Rayf to start school, the catch was if he began school he would lose his services.

That meant, no more home visits with therapists and in school there would only be half hour sessions. I was stuck. Do I send him to school or let him stay home for another year and continue receiving help. Well that day came when I had to go to North avenue to make a decision.

All of the professionals said that school would be the best thing for him, being around other children would encourage him to walk, talk and more, so I agreed. I'll tell you that was the worst mistake I've made in my life.

Rayf started school but began falling behind. I paid the school a visit and it seemed like more of a daycare than anything.

There was no teaching being done and the children in the class were out of control. So I came up with an idea and bought everything I thought he would need such as arts and crafts, learning DVD's, flash cars you name it.

When he'd get home from school, I'd spend an hour working on something with him, he then was able to name some animals, sing a few songs and started trying to feed himself.

Remember the doctors said it was going to be close to impossible for him to be able to do those things. We proved them wrong and we were going to keep proving them wrong.

My son began to walk as long as someone held his hand. So, my brother bought him a medical walker. He was all over the place and all I could do is smile and cry. Rayf had the biggest smile on his face, he was able to get where he wanted to go.

I couldn't thank my brother enough. The walker was something I couldn't afford and the insurance company wouldn't cover it.

I am blessed to have a family who are always willing to help.

Rayf went to school the next day, when he came home he was saying ouch to his leg, well then I noticed he wasn't able to walk with his walker or put pressure on his leg at all. His whole leg was bruised.

I took him to Patient first and the doctor said from the looks of it someone either stepped on him or kicked him. I was furious, I called everyone and no one could give me a straight answer and kept pointing fingers at one another. So this momma filed a police report and pulled my son out of that school. I wasn't going to allow them to do anything to my child again. All I could think is what if they permanently did something to his leg. He just started standing, now what if he never be able to walk completely.

I had to calm myself down an take the doctor advise, to give it a week and if he doesn't seem better bring him back. Good news was that after

five days he was able to put pressure on his leg again. Thank God!

Everyone who knows my son knows he is the happiest baby, you can be in the worse mood and he'll put a smile on your face. He's full of love and joyful energy.

Often people are willing to work with a job or company who tend to people with special needs but often the people who initially wanted to help end up doing the most harm due to the fact that they became overcome by the lack of understanding, love, respect, patience and empathy.

I was just raised to treat people with respect and to treat them the same way I want to be treated. If everyone followed that I think that the world would be a better place.

As I was saying, we continued enjoying the summer, still practicing walking and talking. I even took Rayf swimming.

I remember the therapists saying water therapy would be really good for his muscles, a lot of people actually used that therapy after surgery.

It's supposed to help the healing process. Rayf then began taking a few steps here and there.

Well then, the new school year was going to begin, North ave. ended up placing him in a very good school. They have a five star for their special needs program, I was so excited.

He was finally going to go to a good school, my mom is a teacher and everyone she spoke with said it was an amazing school, they have a lot of hard working people and ones who are top of the line with special needs children. Rayf is required to get transportation due to his disability, well for some reason the bus didn't show up the first day. It really bothered me because Rayf was so excited to go to school, he had his uniform, bookbag and cool new shoes on. Let me add that the school is a good seven miles away and I do not have a license but I refused for him to miss his first day of school. That was not going to happen, so I pushed him in his stroller all of the way there.

This went on for almost a month, so yes, pretty much fourteen miles a day!

Definitely received my exercise, I had to do what I had to do. I knew that if he missed school he was going to fall behind and I wasn't going to allow that to happen.

Finally, the bus situation was straightened out and Rayf began being picked up.

I noticed right from the start how great this school was going to be for him. Homework every day and they actually kept track of his activities for each day. I finally had found a school that seemed like they actually cared about my son.

I was really worried because of his color and due to all of the racial controversy in America, the school is 98% African American but honestly that didn't become a problem. The staff treats us the same way as everyone else. They love Rayf and treat him as family.

Well now that everything was straightened out with the bus, I started working at a sub shop doing dishes, mopping floors or whatever I could do to put some cash in my pocket and to get me out of the house.

One of the days I didn't have to help out so I had decided to visit my parents. I was running around the house with my niece and nephew, next thing you know I hear little footsteps chasing me!

Sure, enough it was Rayf! All I could do was cry, I was able to see my baby walk for the first time!

The look on his face showed he was so excited to be able to run and play with everyone else. He's been non-stop ever since!

I couldn't be more proud of him and yet again we proved him the therapists wrong. He wasn't ever going to be placed in a wheel chair. As soon as he started walking I told everyone every day that I was so happy. It felt like his first step at walking was my first step and each time I see him run and pray I always feel his joy with him, he is my joy and happiness!

Well, that night a guy named Mark began helping out at the same food shop I help out at. He then started telling me about his sister Keilley and her disability she lived with before she had passed away. It felt good to actually have someone who could relate to me, you can talk to a million people honestly though, but if they haven't been through it, they can never fully understand enough to relate.

Mark was so positive about everything and his outlook on life just amazes me. He's one of the most, nicest people I've ever met.

A lot of people wonder how can someone be so positive after going through so much. I always tell them, you never take your problems out on other people. Life is too short to allow a disadvantage to

keep your head down. You have to look above towards the stars and BELIEVE!

www.ingramcontent.com/pod-product-compliance
Lightning Source LLC
Chambersburg PA
CBHW070104210526
45170CB00012B/742